BUNNIES

Kieran Lynn

A PLAY CONCERNING A FARMER'S RADICAL ATTEMPT TO RESTORE HIS LAND TO ITS SUPPOSED FORMER GLORY AND THE DIFFERING REACTIONS OF HIS CHILDREN: OR

BUNNIES

(FOR SHORT.)

OBERON BOOKS
LONDON

WWW.OBERONBOOKS.COM

First published in 2012 by Oberon Books Ltd
521 Caledonian Road, London N7 9RH
Tel: +44 (0) 20 7607 3637 / Fax: +44 (0) 20 7607 3629
e-mail: info@oberonbooks.com
www.oberonbooks.com

A catalogue record for this book is available from the British Library.

PB ISBN: 978-1-84943-467-6
E ISBN: 978-1-84943-699-1

Cover image by Patrick Cullum
www.patrickcullum.com

Visit www.oberonbooks.com to read more about all our books
and to buy them. You will also find features, author interviews and
news of any author events, and you can sign up for e-newsletters
so that you're always first to hear about our new releases.

A Table of Contents

ACT ONE

ACT TWO

Scene 1: In which Max presents a list of native targets, all of which are believed to be harming the land, while Stamper searches for his lost leaflet.

Brief Interlude: In which Eva, Max and Stamper sing a song of regret and progress.

Scene 2: In which Max begins plans to eradicate everything from the land, while Stamper struggles to get out of a fishing net.

Scene 3: In which Stamper tries to save a life and Max reveals a leaflet of his own.

Scene 4: In which Stamper asks Eva for help in stopping his out of control son, only to be discovered in his betrayal by a disappointed Max.

Finale: In which Max sits alone in his newly created perfect world.

Act One

SCENE 1

In which Stamper laments the demise of his land, Eva argues for positivity and Max does nothing.

A large farmhouse dining room. Three chairs around an oak table. There are two doors, one that leads outside, and one that leads to the rest of the house. The place is dirty, unloved, and dark. STAMPER enters, he pulls out a chair and sits on it, it breaks beneath his weight and he falls to the floor.

STAMPER: ...Ow.

EVA enters.

EVA: I told you not to sit in that chair.

STAMPER: No you didn't.

EVA: Didn't I?

STAMPER: No.

EVA: Well, I meant to. It's too late now I suppose.

STAMPER: Yes, I suppose it is.

EVA: I'll fix it later.

STAMPER: Why bother? Why not just let it fall apart? Everything else is.

EVA: Everything is not falling apart.

EVA sits on another, the chair breaks, she falls to the floor.

EVA: Can we pretend that didn't happen?

STAMPER: The whole place is crumbling before my eyes.

EVA: I'll fix both of these later.

STAMPER: If I spent my life fixing all of the things that needed fixing, I wouldn't have time for anything else.

EVA: Maybe if you spent the time you spend complaining about all the things that need fixing, fixing the things that

need fixing, then everything would be fine, and nothing would need to be fixed.

Pause.

STAMPER: You've lost me.

MAX enters, eating a carrot.

STAMPER: Hi Max.

EVA: Hello Max.

MAX: …

MAX stands for a moment, then exits.

EVA: Nice to see you too.

STAMPER: Now where are we all going to sit?

EVA: I can sit on the table.

STAMPER: You're joking aren't you? You'll break your back.

EVA: This table is solid oak.

STAMPER: It might have been solid oak once, but now it's rotting oak.

EVA: Dad, stop being so pessimistic.

STAMPER: That's easy for you to say. You're young. You don't know any different. I remember this land when it was at its best.

EVA begins to exit.

STAMPER: Whoa, whoa, whoa. Where are you going? I was just about to start reminiscing.

EVA: I haven't got time for your reminiscing. I've got work to do.

STAMPER: What work?

EVA: You have just said the place is falling apart, well someone has got to work to hold it together.

STAMPER: And that person is going to be you, is it?

EVA: Well, it definitely isn't going to be Max.

STAMPER: Leave Max alone. Max just hasn't figured out what he wants to do yet. When he finds something he enjoys, you watch, he'll excel at it.

EVA: Let's hope it is fixing chairs.

STAMPER: There is no point fixing them. They'll only break again.

EVA: That's a terrible attitude.

STAMPER: You live in this place long enough and you'll have a terrible attitude as well.

EVA: You don't give *this place* enough credit. I woke up this morning and I heard the birds singing. I looked out of my window and I saw rabbits and deer out in the fields. It was beautiful.

STAMPER: Those beautiful birds eat all of our seeds and shit on the windows. Those deer eat the saplings and break down the fences. They're pests.

EVA: They only eat a little bit.

STAMPER: We shouldn't have to share with them.

EVA: There is plenty to go around.

STAMPER: Like I said, you're young. You think everything is sunshine and rainbows.

EVA: And I hope I keep on thinking that.

STAMPER: Well good fucking luck.

EVA: Thank you Dad. Now if you will excuse me, I don't want to waste another second of this beautiful day.

EVA exits.

STAMPER sits on a third chair, which also breaks beneath his weight.

STAMPER: For fuck's sake.

He sits alone on the floor. A letter is pushed through the letterbox in the front door. STAMPER stands. He picks up the leaflet and reads.

End of scene.

SCENE 2

In which Stamper reveals his dramatic, but possibly practical solution to a problem that may not even exist.

MAX is eating a plum. STAMPER enters.

STAMPER: Where's your sister?

MAX: I don't know.

STAMPER: Go and find her.

MAX: Why do I have to?

STAMPER: Just do it.

MAX exits. A moment. EVA enters.

EVA: Where is Max?

STAMPER: Looking for you.

EVA: But I'm here.

STAMPER: You're here now but a moment ago, when you weren't here, I sent him to look for you.

EVA: Which way did he go?

STAMPER: Out there.

EVA exits, after MAX. MAX enters, from the other door.

MAX: She isn't outside.

STAMPER: Yes she is.

MAX: I've just been there.

STAMPER: She came here.

MAX: In here?

STAMPER: Yes.

MAX: So where is she now?

STAMPER: Gone looking for you.

MAX: But I'm right here.

STAMPER: You are now, but you weren't when she was here.

MAX: I'll find her.

STAMPER: No, for God's sake, wait here. She will be back any second.

Silence.

STAMPER: …So…how are you son?

MAX: Okay.

STAMPER: Good.

Silence. EVA enters.

EVA: There he is.

STAMPER: Thank fuck for that.

EVA: Why did you send me to look for him?

STAMPER: Because he wasn't here then.

EVA: Well he is now.

STAMPER: Of course he is now.

MAX: I can leave again. If that makes it easier.

EVA: I'm not coming to look for you. Not after all that.

MAX: I could tell you where I was going.

STAMPER: We are all here now. That is what matters. Right. Let's begin. First of all let me thank you both for coming to the dining room. I know we don't really spend very much time together as a family these days – And, believe me, I wouldn't call you here unless it was very important. So here goes. I am very pleased to tell you both that I have discovered a solution for all of the problems that we have been having over the last few weeks, months, and years. I'm sure you both know which problems I am talking about.

Pause.

STAMPER: Eva?

EVA: No.

STAMPER: Max?

MAX: What?

STAMPER: Never mind. Surely you have noticed that it seems like the…the quality of life has deteriorated on this land. There is a definite sense of…of…

STAMPER takes a small piece of paper from his pocket, reads it, and continues.

STAMPER: Of growing unease amongst the population.

EVA: What was that?

STAMPER: What was what?

EVA: That you read from?

STAMPER: Nothing. Shut up.

EVA: Have you made notes?

STAMPER: No.

EVA: Have you written a speech?

STAMPER: *(Trying to continue.)* These problems are not always the…the…

EVA: We want to see what that was. Don't we Max?

MAX: What?

EVA: We want to see what he was reading from?

MAX: …No.

EVA: Yes we do.

STAMPER: The point is this place is fucked. I mean look at the state of it. Everything is falling apart. And the problems we are facing are…you are making me forget what I am supposed to say.

EVA: Why don't you read from your leaflet again?

STAMPER: …Fine.

STAMPER takes out the leaflet out, and reads from it.

STAMPER: 'An increasing sense of discomfort and disappointment as to how our once great land ever got this way. It would be easy to believe that such disheartening times have no end in sight, but we are pleased to announce that this is not true.'

MAX exits, unnoticed.

EVA: Where did you get that?

STAMPER: 'The only solution to any problem is to identify and remove its causes.'

EVA: Did someone give it to you?

STAMPER: 'We have identified the cause of this problem, and we ask for your help in removing it.'

MAX enters, eating an apple.

EVA: Did you find it somewhere?

STAMPER: Eva, I have been looking forward to this all morning, and you are doing a great job of ruining it for me.

EVA: I just wanted to know.

STAMPER: It doesn't matter where I got it, all that matters is that I did, and now, if you don't mind, I will get back to where I was. The solution to a problem is to remove its causes. 'And the major cause of this growing list of problems can only be identified as one thing: The introduced species that have made this land their home without invitation.'

EVA: Are you talking about...

STAMPER: Animals. Of course. What else? 'This land is blighted by non-native species which are reeking havoc, and destroying the quality of life for those of us who have a natural right to call this land our home.'

EVA: There can't be that many of them.

STAMPER: That's what I thought, but I began looking and the list goes on and on, and is really quite shocking.

EVA: Like what?

STAMPER: I'm glad you asked Eva. I'm glad you asked.

STAMPER takes out a very long list.

STAMPER: Non-native species, believed to be harming the natural conditions of this land include: The Grey Squirrel, the North American Signal Crayfish, the Red Eared

Terrapin, the American Mink, the Chinese Mitten Crab, the Ruddy duck –

MAX, who has now finished his apple, exits.

STAMPER: The Siberian Chipmunk, the Zebra Mussel, the Indian House Crow, the Egyptian Goose, the Edible Dormouse, the Alpine Newt, the Slipper Limpet –

MAX re-enters.

STAMPER: The African Clawed Toad –

MAX exits.

STAMPER: The Common Pheasant, the Muntjac Deer, the Topmouth Gudgeon, the Canada Goose, the European Rabbit.

EVA: The rabbit?

STAMPER: Yes Eva, it turns out that even the rabbit is an invader.

EVA: But rabbits are so sweet.

STAMPER: They are not sweet, they are bloody Vikings. Coming over here pillaging and raping our countryside.

EVA: The little bunnies?

STAMPER: They may look nice and they may seem harmless, but believe you me, they are doing a lot more harm than good. And that brings me to my next point… The Solution.

MAX enters, with a banana.

STAMPER: Where have you been?

MAX: I went to get an apple.

STAMPER: That's a banana.

MAX: I know. I finished the apple and was still hungry.

STAMPER: Well you have missed the list of animals. Luckily for you, I haven't even started on the list of invasive plants and shrubs.

STAMPER takes out another list, this one is even longer than the last.

EVA: What is The Solution?

STAMPER: Right, yes, I suppose we can skip over the list of plants and shrubs, I can't pronounce most of the names anyway. So...The Solution.

A pause.

EVA: Go on then.

STAMPER: I'm pausing for emphasis.

EVA: Oh, I thought you had forgotten what you were saying.

STAMPER: No.

EVA: You had a strange look on your face.

STAMPER: That is my emphasis face.

EVA: Do it again.

Does.

EVA: That doesn't really look like emphasis. That is more like you are trying to solve a riddle.

MAX: You look surprised.

EVA: I think emphasis would be a little bit more excited.

STAMPER: Never mind that. The Solution.

MAX: Are you going to pause for emphasis this time?

STAMPER: No. I think you have successfully ruined whatever emphasis I might have achieved. I think it would be best if I just got straight on with The Solution.

EVA: Go on then.

STAMPER: The Solution is…to get rid of them.

Pause.

EVA: Get rid of what?

STAMPER: The non-natives.

EVA: What do you mean get rid of them?

STAMPER: You know...

STAMPER motions, wringing a small creature's neck.

EVA: Kill them?

STAMPER: Fuck yes.

EVA: Kill them?

STAMPER: Again. Yes.

EVA: You're going to kill all of those animals.

STAMPER: It is the only way.

EVA: Is that what your leaflet says?

STAMPER: Never you mind.

EVA: Who is putting these leaflets out there?

STAMPER: This is the only way. Unfortunately we have let this problem get so far out of hand that only the most radical of solutions will do. This is my land and I can treat it, and those who live on it, however I want and if you don't like it then you can fuck the fuck off.

STAMPER exits.

MAX: Wow. Exciting stuff.

End of scene.

SCENE 3
In which Stamper begins preliminary reconnaissance for the task at hand, while Eva offers more peaceful alternatives and Max searches for his missing plum.

EVA is trying to fix one of the broken chairs. STAMPER enters with a large pile of papers, photographs, and a few books. (Throughout the scene he pins his information to the back wall. Creating something that looks a little like a police investigation board.)

STAMPER: The more I look, the more unnerving this becomes.

EVA: I fixed the chair.

STAMPER: The more I learn, the angrier I get.

EVA: It's almost as good as new.

STAMPER: A little knowledge really is a frightening thing.

EVA tests the chair. It breaks again.

EVA: Shit.

STAMPER: Leave that. This is more important.

EVA: What is it?

STAMPER: This is Phase One of The Solution.

EVA: Phase One?

STAMPER: Phase One.

EVA: What is Phase One?

STAMPER: Phase One is the planning stage. I've been reading books, putting together lists and learning as much as I can about my new enemies.

EVA: Reading? That isn't like you.

STAMPER: I know. I'm as surprised as you, but I figured that if I am going to do this, I want to do it well. I think you will be surprised at what a good job I've done.

Brief pause.

STAMPER: …Would you like me to show you what I have been doing?

EVA: Not really.

STAMPER: I tried to show Max, but he wasn't interested either.

EVA: He isn't interested in anything.

STAMPER: He told me he had left a half-eaten plum somewhere, and until he finds it, he won't be able to focus on anything else.

EVA: That sounds like Max. Only one thing on his mind at any given time.

STAMPER: Before a few days ago I hardly ever saw him eating fruit, now he seems to be eating it every minute.

EVA: He gets like that.

STAMPER: Please Eva, let me show you what I've been doing. Please. I've worked so hard.

EVA: Fine. Go ahead.

STAMPER: Thanks Eva.

STAMPER assumes a lecturer-like position. He takes a moment to get himself and his pages in order, while EVA takes a seat facing him.

STAMPER: I have divided my targets into three categories: Land, air and water. I have listed the categories in order of importance, land being the most important, or Priority One, water being the least important, or Priority Three. Within each of the categories I have listed the species in order of those, which I believe to be the most harmful, based on a complicated ranking system which takes into account the negative effects on the land itself, on other species and its overall population, and thus I have decided which are most important targets. Now, since land is Priority One, the most harmful species in Priority One is the most dangerous of all, and will be the first major target for The Solution. I can now reveal that Priority Number One, top of the list, tip of the iceberg, public enemy numero uno is… The rabbit!

On this STAMPER pins a photograph of a rabbit on the wall, right in the centre.

STAMPER: Impressed?

EVA: I don't know what I am.

STAMPER: Now, I believe that the most effective way to catch a rabbit is to use the humble snare trap. Now everybody knows that the secret to a snare trap is positioning. That's the key. So we must now enter Phase Two, which is really the second half of Phase One, but I don't want to call it Phase One and a Half, so for neatness' sake, I am calling it Phase Two. Phase Two is a more detailed study of our enemies. We must learn where they live, where they eat, where they move, only then can we begin laying out our traps and begin Phase Three: All-out war.

EVA: Dad?

STAMPER: Yes.

EVA: Why do you keep saying we?

STAMPER: What do you mean?

EVA: I'm not helping you with this.

STAMPER: You're not?

EVA: No I'm not! I'm not going to help you kill a bunch of innocent animals.

STAMPER: They're not innocent Eva.

EVA: There's no way I'm helping you.

STAMPER: I thought we would all work together as a team.

EVA: What made you think I would help? As soon as you mentioned this idea I was against it.

STAMPER: I thought that was a gut reaction. I hoped that in time you would look at it logically, and see what an excellent idea this actually was.

EVA: Well I haven't. I still think it is cruel, I still think it is unnecessary and I still think that you shouldn't do it.

MAX enters.

STAMPER: Did you find your plum?

MAX: I don't have a plum.

STAMPER: I know you don't have one. You've lost one.

MAX: Where?

STAMPER: I don't know. You don't know. Nobody knows. If somebody knew where it was, then it wouldn't be lost, would it?

MAX: I suppose not.

STAMPER: Forget about the plum.

MAX: I already had.

STAMPER: I need to talk to you about something very important.

MAX: Now?

STAMPER: Yes.

MAX: What about my plum?

STAMPER: I thought you had forgotten.

MAX: I had, but now you've reminded me.

STAMPER: Eva has just informed me that she will not be helping me affect The Solution, and while I am disappointed, saddened, frustrated, betrayed...

EVA: Dad!

STAMPER: I nonetheless must accept that I cannot force her to help if she doesn't want to. This will, however, mean that there is more work for you and me.

MAX: I'm not getting involved.

STAMPER: Unbelievable! Absolutely unbelievable. Here I am trying to make life better for my two children, trying to bring us all together and do something that will drastically increase our quality of life. All I ask in return is a little help and what do I get? Nothing.

EVA: I think that there must be a more peaceful way of achieving what you want to achieve.

STAMPER: Well you are wrong. I have been waiting my whole life for a peaceful solution, and it has never appeared. While I was waiting the problems have been getting worse. Now I will not wait any longer, I am going to do something about it, and if you won't help me then I will do it all by myself.

STAMPER exits.

MAX: The shed. That's where I left my plum.

MAX exits.

End of scene.

SCENE 4
In which Stamper begins to affect his solution and experiment with taxidermy, while Max tries to remain uninvolved and Eva attempts to change her father's mind.

EVA is polishing the dining-room table. She looks as though she has been working hard for some time.

EVA: Much better.

STAMPER enters with a handful of dead rabbits, he drops them on the newly cleaned table.

STAMPER: Jackpot!

EVA: Dad!

STAMPER: Day one and Stamper takes an early lead.

EVA: Those poor things.

STAMPER: This shows you the extent of the problem. There are so many of these little fuckers they are practically queuing up to get in my traps.

EVA: Poor little things.

STAMPER: Everyone says animals are more cleverer than we give them credit for, but they really aren't. I mean I put three traps side by side, and caught three rabbits in them. You would think that the third one would see the first and the second one dead and think 'Something is not right here, I'm going to go somewhere where there aren't two dead rabbits.' Instead the silly little critter marches straight into the third trap.

EVA: I hate seeing dead rabbits. It makes me think that you've probably left lots of little baby bunnies without any parents.

STAMPER: You can guarantee that. There is no stopping these things. They breed like... Oh, what's the expression? It's gone. Anyway I'm going to take these into the shed.

EVA: What are you going to do with them?

STAMPER: I was up all night thinking about that. I am going to have a lot of dead shit on my hands, I thought, what am I going to do with it all? I can eat the meat, that's not a problem, but it seems a shame to waste so many pelts – That is what people like me call the furs, by the way. Pelts. It's a technical term. So I thought, what am I going to do with all the pelts? Well, I have come to an excellent conclusion. I went out this morning and bought all of the chemicals, tools, bits and pieces and I think I'm ready to go.

EVA: Please don't say what I think you are about to say.

STAMPER: I'm going to stuff the little fuckers!

STAMPER exits. A few moments. MAX enters, from the same place STAMPER exited, pursed by STAMPER, who no longer has the animals, but now carries a large knife.

STAMPER: Skinning is a useful skill for a young man to learn. And while we are on the subject, it would please me greatly if you would come out later and reload the traps. One day you will inherit this land and you need to know how to take care of it, you need to know how to defend it.

STAMPER exits, to resume his skinning.

MAX: Hi.

EVA: Hi.

Silence.

MAX: …See you later then.

MAX begins to exit.

EVA: Max, wait.

MAX: What?

EVA: What are we going to do?

MAX: About what?

STAMPER enters, he wears a white apron, on which is a little blood.

STAMPER: I'm going to get some scissors. They've got bloody thick skin those rabbits.

STAMPER exits, a different way.

EVA: About him.

MAX: What about him?

EVA: We can't let him start killing all the animals on the land.

MAX: Why not? It is his land.

EVA: It is ours as well.

MAX: Well, it is more his.

EVA: Why is it?

MAX: I don't know. He is older.

EVA: It's that leaflet that has done this to him.

MAX: He'll change his mind.

EVA: He won't change his mind Max. No one ever changes their mind.

MAX: I change my mind all of the time.

EVA: You never make up your mind in the first place.

MAX: I do.

EVA: Really?

MAX: I think so…maybe…no, probably not actually.

STAMPER enters, with a large pair of scissors.

STAMPER: Now we will see who is boss.

STAMPER exits, into his shed.

EVA: The problems on our land aren't all because of foreign species, are they?

MAX: Maybe.

EVA: Exactly… Wait. What?

MAX: Maybe they are. How am I supposed to know who is to blame?

EVA: Max, I agree, things aren't exactly perfect here, and something does need to be done. But there has to be a solution that is less violent.

MAX: He isn't *that* violent.

STAMPER enters, he has a lot more blood on him, and carries a book.

STAMPER: Eva, the book says I have to gently force the eyes out of the sockets, but my fingers are too big. Have you got any tweezers I can borrow?

EVA: No.

STAMPER: Then would you do it for me?

EVA: Will I do it for you?

STAMPER: Well, you've got girly little fingers.

EVA: What do you think Dad?

STAMPER: …I wish you would be a team player.

STAMPER exits.

EVA: This is going to get worse unless we stop it.

MAX: You can do it. I don't want to.

EVA: We have to do something Max. Everyone has to do something.

MAX: Why don't we leave him to get on with what he wants to do, and then that means that we can do what we want to and everyone will be happy?

EVA: Because what he is doing is wrong.

MAX: How will we know unless we give him a chance?

EVA: We have to do something now Max. Before it is too late.

STAMPER enters, he is now drenched in blood and he has a rabbit's skin over his hand like a puppet.

STAMPER: Look at this. *(As Mr Bunny Rabbit.)* Hello kids. My name is Mr Bunny Rabbit.

EVA: Dad that is disgusting.

STAMPER: *(As Mr Bunny Rabbit.)* I sure wish I had never ruthlessly invaded this land.

EVA: I can't believe you sometimes.

STAMPER: What? I'm only playing around. What do you think Max? *(As Mr Bunny Rabbit.)* Are you afraid of little Mr Bunny Rabbit?

MAX: Not really.

STAMPER: A typically emphatic response from my only son.

EVA exits.

STAMPER: Where is she going? *(As Mr Bunny Rabbit.)* Where are you going Eva? Don't you want to be my friend?

MAX begins exiting.

STAMPER: *(As Mr Bunny Rabbit.)* Max, why don't you come and help me with the skinning?

MAX: No thanks Mr Bunny Rabbit.

STAMPER: *(As Mr Bunny Rabbit.)* You can help me pluck the pheasants?

MAX: I don't want to.

STAMPER: *(As Mr Bunny Rabbit.)* Do you want to come and check the traps with me?

MAX: Not really.

STAMPER: *(As Mr Bunny Rabbit.)* You've got to do something.

MAX: Don't you start!

MAX exits.

STAMPER: Start what?

Alone with Mr Bunny Rabbit.

STAMPER: Come on Mr Bunny Rabbit. Let's go and start on your brothers and sisters.

STAMPER exits.

End of scene.

BRIEF INTERLUDE
In which Stamper sings a song
in celebration of his solution.

STAMPER has a large metal basin in front of him. His arms, apron and possibly face are covered in blood. He is skinning rabbits.

STAMPER:

They're ruining our historic land
With their destructive habits.
There is only one solution,
That's to kill the fucking rabbits.

I like to rip their heads off.
I like to eat their meat.
My diet once was balanced
Now rabbit's all I eat.

We all agree this land is full,
There's no room to cohabit.
We want our land the way it was
So kill every fucking rabbit.

No longer will us men stand by
And watch our land be ravaged.
It's time to take our country back
And kill the fucking rabbits!

End of interlude.

SCENE 5
In which Eva begins a well-meaning, if under-planned, movement of resistance, while Max attempts to remain uninvolved and Stamper decides on a recipe for black pudding.

The dining room is empty. EVA enters, looking for STAMPER, when she sees no one is there she exits again. She then enters holding a large suitcase, which is filled with living animals and is moving accordingly. EVA peers in the suitcase.

EVA: Stop fighting!

She leaves the case, before exiting the way she came. A moment. MAX enters eating a pear. He sees the suitcase. He looks around. He continues to walk. Just before he leaves we hear the cluck of a pheasant, from the bag. MAX stops. He searches around him. Another cluck. He knows the source of the cluck, and approaches it very slowly... He places his hands on the zips. Just as he is about to unzip...

EVA: *(Loudly.)* Max! Thank God.

EVA enters carrying another suitcase full of animals.

EVA: Give me a hand with this.

MAX: That bag clucked at me.

EVA: Give me a hand.

MAX: Why did the bag cluck at me?

EVA: I have begun an underground railroad. For the bunnies.

The bag clucks.

EVA: And the odd pheasant.

MAX: How did you get them?

EVA: I laid out a few traps of my own.

MAX: What are you going to do with them now?

EVA: I am going to take them to the edge of our land and release them. And you are going to help me.

MAX: Me?

EVA: Yes.

MAX: But I am eating.

STAMPER enters wearing his bloody apron and holding a cookbook.

STAMPER: Here you two are. I wanted to ask you a question.

EVA: Now?

STAMPER: Yes. Are you busy?

EVA: Max is eating.

STAMPER: He can eat and listen at the same time. Can't you?

MAX wasn't listening, he was eating.

MAX: …Were you talking to me?

STAMPER: I am about to make my first batch of black pudding and I need a bit of help choosing which one to make.

EVA: Can we talk about it later?

STAMPER: No. I figured I am going to have a lot of blood on my hands and I don't really know what to do with it all. So I am going to make something useful that we can all enjoy, but there are a few more types than I thought and I don't know which one to plump for.

MAX: I love black pudding.

EVA: Make it quick.

STAMPER: There is the standard one. I suppose that would be all right.

EVA: Yes.

STAMPER: But it's a little boring.

MAX: It's a classic for a reason.

EVA: Walk before you can run.

STAMPER: Then there is one with apple and cinnamon.

MAX: That sounds nice.

STAMPER: I don't think I have got any cinnamon.

EVA: I think the first one.

STAMPER: There is this one which has nutmeg and…cain…
cay…cayenne. I don't even know what that is.

MAX: Me neither.

EVA: I think it is always good to begin at the beginning.

STAMPER: This one is white. White pudding. That sounds
much better than black.

MAX: That does sound better.

EVA: I think you should make the standard one first. Then
once you have mastered that you can move on to the more
complicated ones.

STAMPER: Yes, I should start at the beginning. Quite right.

There is a quiet cluck and a wriggle from the bag.

STAMPER: …Are you going somewhere?

EVA: No, just throwing these old cases away.

STAMPER: They're my cases.

EVA: Yes, but we never use them.

STAMPER: I use them all the time.

EVA: When?

STAMPER: I sometimes use them.

EVA: When was the last time you used them?

STAMPER: Fine, I never use them! The point is that they're mine and I don't want you to throw them away. Now go and put them back where you found them.

A cluck.

STAMPER: Don't you make stupid noises at me young lady. Put them back.

EVA: I will in a minute.

STAMPER: Put them back now, or I will do it myself.

EVA: I will…I'm just…I'm…I need a moment to think.

STAMPER: About what?

EVA: About…I don't know.

STAMPER: Fine. I'll do it.

EVA: No! Max and I will put them back, we were just…we were in the middle of a conversation. Weren't we Max?

MAX: What?

EVA: In the middle of a conversation?

MAX: …Who?

STAMPER: It was obviously of the utmost importance.

EVA: We will put the cases away in a minute, won't we Max? When Dad has gone somewhere else?

MAX: I'd rather not get involved.

STAMPER: Involved in what?

A loud cluck.

STAMPER: What was that?

EVA: What?

STAMPER: I heard a bird.

EVA: Must have been flying overhead.

The suitcase begins moving violently.

EVA: Probably a Lark or a Starling or something.

STAMPER: Eva?

EVA: I think we have Magpies nesting nearby.

STAMPER: Eva?

EVA: See a lot of Thrushes around this time of year.

STAMPER: Eva, that case is moving.

EVA: Is it? No, that isn't movement. I put some things in there, they must have shifted.

Loud cluck.

EVA: I put some chickens in there. I thought they would like it.

STAMPER: What is going on here?

EVA: Nothing. Just taking my chickens for a walk.

STAMPER: Eva… Step away from the case.

EVA does. STAMPER slowly approaches. He unzips and takes a peek inside.

STAMPER: Holy fucking moley! Eva, you did this?

EVA: …Yes.

STAMPER: I'm so…I can't find…this is…come here!

He gives her a big hug.

STAMPER: I am so proud of you. You have made an excellent contribution to my solution. This is exactly what I wanted to happen. To work in tandem with my two children. I am so proud of you Eva. Now let's get all these killed, skinned and in my black pudding!

STAMPER lifts both cases and exits.

End of scene.

SCENE 6

In which Eva steals Stamper's leaflet and in an attempt to influence her brother, though having the opposite effect, criticises its statements, while after an inspirational dream Stamper vows to broaden the horizons of his solution.

Night. MAX enters the dining room. He notices one of STAMPER's dead rabbits, which has been left on the table. MAX approaches it cautiously. He produces a small knife from his pocket. He begins hacking away at the rabbit, chopping it up and exploring its insides. He is getting more and more manic as the moments go on, but maintains the same emotionless expression. There is blood and guts everywhere when EVA enters holding STAMPER's leaflet.

EVA: Max?

MAX: …

EVA: Max?

MAX: …

EVA: Max!

MAX: What?

EVA: What are you doing?

MAX: Dad left this rabbit here. I was cleaning it up.

EVA: Didn't look like it.

MAX: What do you want?

EVA: Look at this.

MAX: What is it?

EVA: It's his leaflet.

MAX: Where did you get that?

EVA: I took it from his room.

MAX: We're not allowed in his room.

EVA: I know. I went in there while he was sleeping.

MAX: You stole it?

EVA: I borrowed it.

MAX: No, you stole it.

EVA: All right I stole it.

MAX: Eva, why do you care so much? It isn't like he is doing anything that affects you.

EVA: It affects us all.

MAX: No it doesn't. If he was going around killing native girls I could understand why you would be upset. I'd be upset myself. But they are just a bunch of useless animals, and there really are plenty more of them, so why do you care?

EVA: Max, I know you don't want to help me, but I can't stop him on my own.

MAX: You've hardly even tried.

EVA: Please, read the leaflet. I know that when you see what is written here that you'll help me. And if, after reading it you still don't want to, then I won't bother you again.

MAX: ...Fine.

MAX reads the leaflet. Silence.

MAX: Hmm.

EVA: I know.

MAX: Hmm.

EVA: Tell me about it.

MAX: Hmm.

EVA: I couldn't believe it either.

MAX: Honestly, I think it makes a lot of sense.

EVA: What! I don't believe it.

MAX: *(Reads from leaflet.)* 'Indigenous species are set to become a minority well within fifty years, resulting in a big loss to our national heritage and identity. An increase in unwelcome life puts increasing pressure on systems that have evolved to benefit only those native to our land thus rendering these systems totally ineffective.' It makes perfect sense.

EVA: You don't mean that.

MAX: Life here is not very good Eva. It's as simple as that.

EVA: I know.

MAX: And here we have people who are offering a reason why, and are proposing a potential solution. And you want to stop them, just because you think that they are not being fair? Is that it? Is that your whole argument? That you don't think it is fair?

EVA: No.

MAX: And what would you do instead? These people are providing a solution. What is your solution?

EVA: I don't know.

MAX: Exactly. You don't know.

STAMPER enters.

STAMPER: I thought you were awake. I heard you talking. I'm a very light sleeper.

Pause.

STAMPER: Are you having a midnight feast?

EVA: No.

STAMPER: You used to have those all the time.

EVA: No we didn't.

STAMPER: Didn't you? I wouldn't know, your mother always used to look after you at nights. Nights were my time. Still are. Now days are my time as well. All time is my time.

Pause.

STAMPER: I had a dream. That's what woke me up really. A dream that this land was like it used to be. Like I remember it being when I was a child. The sky was blue, the grass was green and the sun was always shining. I would gaze out the window and see Chaffinches and Robins eating berries from the bushes. I would catch Great Crested Newts and Natterjack Toads in the pond at the bottom of the garden. In the spring, I watched the

Mountain Hares leaping higher than you ever dreamed imaginable. I watched the Red Deer stag raising its majestic head to salute the coming of a new day. Life was simple. Life was beautiful. Life was the way it should be on this land. On my father's land. On my land.

MAX: I'll help you Dad.

STAMPER: You will?

EVA: You will?

MAX: I'll help you. I'll load the traps, I'll help with skinning, I'll go out shooting with you, I'll do whatever it takes. I'll help you.

STAMPER: Max.

EVA: Max!

MAX: I want life to be like that again. I'm tired of hating my home. And I'm tired of wishing I lived somewhere else. I want it to be simple and beautiful. I want to watch birds in the garden, see Red Deer, and majestic mornings. I want that.

EVA: This isn't the way to get it Max.

MAX: Well it isn't going to get better by itself. We have to do something, and this is something.

STAMPER: …I don't know what to say.

EVA: Neither do I.

MAX: Neither do I.

STAMPER: Son, you have made me the happiest, proudest Father in the world. Finally I can work hand in hand with one of my children. And look at that, the sun is rising. The sun is rising again on this land. And I think it is going to be a beautiful day.

End of scene.

BRIEF INTERLUDE
A montage to show the passage of time and the growing
sincerity of Stamper and now Max's Solution.

*Loud music plays. EVA sits at the kitchen table. STAMPER and
MAX quickly and with pleasure, are bringing in taxidermy, animal
skins, weapons, bones, traps, nets, and cages, as much as possible.
Their clothes also improve, both could wear fur coats. At some point,
EVA, having had enough, exits. In the end the dining room should
be completely transformed. The dining room should be filled with
spoils of their war. When the transformation is complete STAMPER
and MAX sit down to rest.*

SCENE 7
In which Stamper and Max discuss plans for the
expansion of their Solution, and Eva tries to leave home
in search of a brighter future.

*In the midst of the taxidermy sit MAX and STAMPER. Their clothes,
once shabby and torn, are now new. They sip whiskey and MAX
eats a piece of meat. Mr Bunny Rabbit is back on STAMPER's hand.*

STAMPER: *(As Mr Bunny Rabbit.)* You've got to admit, it's
getting better, a little better all the time.

MAX: Can't get much worse.

STAMPER: I couldn't have done this without you son.

MAX: Nor I you.

STAMPER: You took a while to get going, but once you get
going, there is absolutely no stopping you.

MAX: I've never felt like this before.

STAMPER: *(Mr Bunny Rabbit.)* He has found his calling.

MAX: I feel like I have been waiting for something like this to
come along my whole life. Something I could really get my
teeth into.

He takes a bite of his meat.

STAMPER: Well I am very proud of you. We make a good
team. In fact, we will have to begin thinking about what

to turn our attention to next, I think we're coming to an excellent conclusion on this issue.

MAX: I've already been considering that pops.

STAMPER: He has already been considering it? What do you think about that Mr Bunny Rabbit? *(As Mr Bunny Rabbit.)* I think this is the most proud I have ever felt. *(As himself.)* Do tell my boy.

MAX: Don't mind if I do.

STAMPER: Hold on.

STAMPER pulls one of the larger animals towards him and places his feet on its back.

STAMPER: You were saying.

MAX: Thank you. Well, now that we have almost dealt with the problem of the unwelcome visitors, my thoughts are that we should look to increase the range and effectiveness of our Solution.

STAMPER: *(As Mr Bunny Rabbit.)* Interesting.

MAX: So far our Solution has primarily been focused on species that are not native to this land, in removing them we have found a new wealth of opportunity for ourselves, as well as native species.

STAMPER: Quite correct.

MAX: It seems to me that we can increase this trend, and thus continue to improve the quality of life, if we continue to remove species, that though they may be native, are deemed unwanted.

STAMPER: Remove native species?

MAX: Only those that we do not want. My view is that we need to find a new system of grading for the native species, ranging from the most welcome to the least welcome, and begin removing those at the bottom of the list.

STAMPER: Are there very many native species that are unwanted?

MAX: I didn't think so, but I have begun doing a little research, and let me tell you the list is quite shocking.

STAMPER: I look forward to hearing it. I am confident that with us working together, we will soon have the land as good as it has ever been.

The two men 'Cheers' their glasses.

STAMPER: Cheers.

MAX: Cheers.

Pause.

MAX: There is one more thing I would like to discuss.

STAMPER: *(As Mr Bunny Rabbit.)* I am all ears.

STAMPER laughs at his own joke.

MAX: Eva.

He stops laughing.

STAMPER: …What about Eva?

MAX: Eva has proved to be nothing but a hindrance and a distraction to our cause. She has shown indignation and even attempted sabotage. Up until now we have been tolerant, both of us believing that sooner or later she will come around to our way of thinking. My question is…what if she does not? As our success continues, her frustration increases, and with every day that goes by she gets more and more extreme in her resistance. Now I'm not saying that she will try to aid our enemies…but she might. And I am not saying that she will give advance warning to those who we are about to pursue…but she might. I am not even suggesting that she might try to personally restrain, or even harm, one of us…but she might. What I am saying, and what I do not believe can be argued, is that so far she has been the single greatest opposing force we have encountered and she has been the only obstacle on an, otherwise, perfect journey to where we are right now. I believe that, if we were smart, we would prevent her from going any further in her resistance.

STAMPER: *(As Mr Bunny Rabbit.)* He sounds so serious all of a sudden.

MAX grabs Mr Bunny Rabbit off STAMPER, and loses his temper slightly.

MAX: I am being serious Dad.

Pause.

MAX: We need to do something about this.

STAMPER: I don't know Max.

MAX: It is not an easy decision to make. I understand. It's not easy for me to even say the words I have just said, and yet they must be faced. I fear that it is only a matter of time before Eva does something drastic. I only hope that we can stop her, before she does.

EVA enters, she has a bag packed.

MAX: Where are you going?

EVA: I am leaving. I can't stay here anymore.

MAX: What is wrong with here? This is the best we have ever had it.

STAMPER: He's right. Look at us, we're thriving. This is exactly what we have always wanted.

EVA: What you have always wanted.

MAX: Did you not want our lifestyles to improve?

EVA: Of course I did. But not like this. It was bad enough when it was just him killing a few rabbits, but it has gone too far with you helping him out.

MAX: I am not helping him out. We are business partners.

STAMPER: I am the business and he is the partner.

A shorter laugh.

MAX: You can't leave Eva.

EVA: I'm going somewhere better.

MAX: You do talk some shit Eva.

EVA: …Goodbye.

STAMPER: There is nowhere better Eva.

EVA: I'd like to find out for myself.

STAMPER: You're very young Eva. You're an idealist.

MAX: In other words, you haven't got a fucking clue how life is in this world. It's kill or be killed. It's eat or be eaten. And we are eating.

EVA: Don't you tell me about the world Max. Not you.

MAX: What is that supposed to mean?

EVA: Look what you have done.

MAX: We have made it better.

EVA: Look around you Max, there is hardly anything left.

STAMPER: You're like your mother Eva. She believed in all that. She believed in a world that is perfect for everyone. I'd tell her she was dreaming. She would never listen. You don't find a perfect world Eva, you build it. You build with your own hands, and your own sweat. You build it out of blood and bricks. You build it on the bodies of those who stand in your way. It's not nice Eva, but it is true, believe me.

EVA: No, it can't be like that.

STAMPER: It is, my love. I'm only trying to help you. The further you go from this land you won't find things any better, you will find them far worse. Here you are safe. We can protect you. You are with your own.

Silence.

EVA: No, this isn't right. You can't choose who lives and who dies. You don't have that power. I have to go. I have to. I can't stay here. Not now. Not like this.

EVA picks up her bag and makes to leave. MAX blocks her exit. She tries to move past him. He moves into her way. She tries again.

MAX: You're not going anywhere.

EVA: Max, get out of my way.

MAX: You're staying here.

EVA: Max!

MAX: We cannot let you leave Eva. It would be too big a risk to our plans.

EVA: Plans? What plans?

MAX: We plan to expand The Solution. And we will not have it ruined by you. So you are staying here.

EVA: No Max, I am leaving.

MAX: No. You are not.

EVA: Dad, tell Max to move out of me way.

STAMPER: …

EVA: Dad, tell him to let me out.

STAMPER: …

EVA: Dad, tell him to let me go.

> *MAX grabs EVA, she fights a little.*

MAX: It is best that you stay here with us Eva.

EVA: You can't keep me prisoner.

MAX: This way we can protect you.

EVA: The only thing I need protecting from is you. Dad?

STAMPER: You must see that everything I do, I do for your own good.

EVA: …

STAMPER: Tie her up.

> *End of scene.*

FINALE

In which Stamper and Max sing a duet in celebration of their success and the advancement of The Solution.

> *STAMPER alone. Sings.*

STAMPER:
> I am a simple man.
> I run a simple land.

It's small and it's quaint yet
It's recently tainted
With life that it shouldn't withstand.

I tried to endure the disgrace.
I watched as my land was debased.
I was prepared
To live life impaired,
I thought I was condemned to this fate.

Then I started killing,
And suddenly the world seemed so fair.
When I started killing
There seemed to be a sweetness to the air.

My land became what it should be
A land that exists just for me.
The land that I own
Feels much more like my home
And the reason is very simply

Because I started killing.

I had abandoned all hope.
I thought that I could not cope.

My plants had no chance as the critters advanced,
My seeds would be feed for pigeons and grebes,
My crops would be scoffed by pheasants and coughs,
My fields' every yield became foreigners' meals.

I thought I would die without knowing why,
I was completely, totally outnumbered by,
creatures I every day wished that would die
and then I discovered something I should try...

MAX enters, he wheels on EVA, who is thoroughly bound and sat in a wheelchair.

MAX: *(Spoken.)* Something *we* should try.

STAMPER: *(Spoken.)* Ah yes. Something *we* should try.

MAX joins the song.

STAMPER/MAX:

So we started killing.
The land began improving every day,
Because we started killing
Everything began to go our way.

The land became our home once more,
As we drove those fuckers from our door.
Plenty of fur, plenty of meat,
Plenty to wear, plenty to eat,
And we've plenty of killing left in store.

Now that we've started killing
The future looks cheery and bright.
Because we've started killing
Everything looks like it will come out right.

The improvements are plain to see,
The future looks so good to me,
We live life as it is meant to be,
And the reason is just because we...

Started killing.
End of Act One.

Act Two

In which Max presents a list of native targets,
all of which are believed to be harming the land,
while Stamper searches for his lost leaflet.

*The dining room. MAX is reading STAMPER's leaflet. After a moment,
STAMPER enters, and MAX, quickly, hides it.*

STAMPER: I can't find my leaflet. Have you seen it?

MAX: No.

STAMPER: I've looked everywhere.

MAX: You don't need it.

STAMPER: I can't remember the last time I saw it.

MAX: Dad! You don't need it anymore. It is obviously lost. So
forget about it.

STAMPER: …What did you want to see me about?

MAX: We are ready to begin Part Two.

STAMPER: Part Two of what?

MAX: The Solution. I have been preparing this all morning,
and am now happy to present to you, Part Two.

MAX pauses for emphasis.

STAMPER: I am aware that you are pausing for emphasis, by
the way. I want you to know that.

MAX: Part Two.

STAMPER: Because when I paused for emphasis, you ruined it,
but I am letting you have your emphasis.

MAX: Thank you. So. Part Two.

MAX pauses for emphasis again.

STAMPER: Although I think you need to work on your
emphasis face. You look like are about to shit yourself.

MAX: Part Two. I have compiled a list of native species that are believed to be damaging the natural conditions of life on this land. These will be the major targets in Part Two of The Solution.

MAX takes out a list.

MAX: Native species believed to be harming the natural conditions of this land include – The Wood Pigeon, the Brown Rat, the European Polecat, the Lesser Spotted Woodpecker, the Greater Horseshoe Bat, the Northern Pike, the New Forest Pony, the Red Fox, the Eurasian Badger, the Roe Deer, the Common Mole, the West European Hedgehog, the Natterjack Toad / ...

STAMPER: The what?

MAX: The Natterjack Toad.

STAMPER: But they're my favourite animals.

MAX: Well, I'm afraid to say that your favourite animal is a wanted criminal in this land.

STAMPER: What is it doing wrong?

MAX: What is it doing right?

STAMPER: What is it doing at all? It's a toad.

MAX: It is harmful and it will be removed.

STAMPER: No, please Max, couldn't we just leave off them?

MAX: Remember when Eva wanted to 'Just leave off' the rabbits?

STAMPER: Yes.

MAX: What did you tell her?

STAMPER: I told her no.

MAX: Exactly. All of these species have been judged to be harmful in some way to the conditions and quality of life on this land. They are all part of Part Two of The Solution, and will be dealt with accordingly.

STAMPER: Please Max?

MAX: No. Now, a lot of these creatures are very different from what we have become accustomed to trapping, so we may have to be a little more inventive in our techniques. Also, due to the growing list of traps placed and species hunted, we will divide into two teams. I will be Team Shotgun, taking care of everything that flies, and the larger mammal species, and you will be Team Hammer, taking care of fish, amphibians and smaller mammals. Ideally, Eva would have taken Team Shotgun, and I would have been the general manager and supervisor of all operations, but Eva is still not coming around to my way of thinking.

STAMPER: Our way.

MAX: Yes our way. So, for now, I take Team Shotgun. We will meet up every day at approximately 0900 hours to discuss the day's objectives, tactics and anything that we can do to aid one another. I must stress that although we are in two teams, we are not in competition in any way, and we are to support and help each other as much as we can. I have even come up with a little slogan to help us remember that we are working together. Would you like to hear it?

STAMPER: Yes.

MAX: ...If one team is winning, both teams are losing.

STAMPER: Nice.

MAX: Thank you. I will have that painted up in large letters and hung on the wall as an inspirational reminder that we're in this together.

MAX puts one hand out in front of him.

A brief silence.

STAMPER: What's that?

MAX: I want you to put your hand on top of mine.

STAMPER: Why?

MAX: And then we say Team! And lift our hands together.

STAMPER: Oh.

MAX puts his hand out again. STAMPER tentatively puts his hand on top of MAX's.

MAX: On three.

STAMPER: Okay.

MAX: One… Two…

STAMPER: Team!

MAX: After three.

STAMPER: You said on three.

MAX: I meant after three.

STAMPER: Then you should have said that.

MAX: I thought you would have known. Let's do it again.

MAX puts his hand out. STAMPER does too.

STAMPER: Is it my turn to check on Eva by the way?

MAX: Yes. I did it last night.

STAMPER: Was she okay?

MAX: See for yourself. So, after three.

STAMPER: Yes.

MAX: One… Two… Three…

STAMPER/MAX: Team.

They lift their hands up.

MAX: I'm glad we did this.

MAX exits.

End of scene.

BRIEF INTERLUDE
In which Eva, Max and Stamper sing a song
of regret and progress.

EVA remains tied up. She sings.

EVA: Oh it is sad.

It is just so sad.

I no longer hear the birds singing,

I no longer see the hare springing,
All I loved is dead.

MAX: Oh this feels good.
This feels oh so good.
When I pierce their bodies with my knife,
When I feel them slowly losing life,
Blood rushes to my head.

EVA: Nothing will survive.
Nothing will survive.
No more baby bunnies on the lawns,
No more calves and no more fawns,
Nothing will survive.

MAX: Oh I am alive.
I feel so alive.
I have a purpose, now I have a goal,
To kill every rabbit, mouse and mole.
I feel so alive.

MAX/EVA/STAMPER: Oh it will not end.
It will never end.

EVA: When I see them I cannot understand.

STAMPER: This has gone much further than I'd ever planned.

MAX: What I'm doing is best for me and my land.

MAX/EVA/STAMPER: This will never end.

End of Interlude.

SCENE 2

In which Max begins plans to eradicate everything from the
land, while Stamper struggles to get out of a fishing net.

*STAMPER is sat at the table, he is untangling a large fishing net. His
hands are both stuck in the net. He pulls one to free it, but all this
does is drag the other one, causing him to hit himself in the side of
the face. He almost does the same thing again. The more he struggles
the more tangled he becomes. He places his hands on the table, and
uses one of his feet to try and force the net off. His foot gets tangled in*

the net. He hops around the room trying not to fall over. Eventually he finds solace on the table.

STAMPER: ...Shit.

MAX enters, he carries a painted sign, which reads 'If one team is winning, both teams are lost.'

MAX: What do you think of this?

He pins it to the wall.

STAMPER: If one team is winning, both teams are lost? That doesn't make sense. I thought it was – Both teams are losing.

MAX: I changed it.

STAMPER: Why?

MAX: Because I ran out of paint. What are you doing?

STAMPER: I'm untangling this fishing net. At least I am trying, but it is far more tangled now than it was when I started.

MAX: Fishing nets are a reasonable idea.

STAMPER: That's what I thought.

MAX: A quite reasonable idea.

STAMPER: And then I started untangling one.

MAX: A little primitive though.

STAMPER: Primitive?

MAX: We need newer methods.

STAMPER: If it ain't broke don't fix it.

MAX: It isn't about it being broke.

STAMPER: Good, because this net is definitely broke.

MAX: It is about a different objective.

STAMPER: What do you mean?

MAX: Fishing nets are used because they are the best way to catch fish.

STAMPER: As long as they are not tangled, yes.

MAX: But we aren't trying to catch fish.

STAMPER: You're not, but Team Hammer is.

MAX: No it's not.

STAMPER: Then why I am wrapped up in this fucking net.

MAX: We aren't trying to catch fish, we're trying to kill fish.

STAMPER: Max, can we continue this conversation when I am not lying on a table wrapped in a fishing net?

MAX: I've got an idea.

MAX exits.

STAMPER: Is it to get me out? Max? Max!

STAMPER rolls over, he falls of the table.

STAMPER: ...Ow!

MAX enters, carrying a large, coloured container.

MAX: Dad?

STAMPER: Hello Max.

MAX: Do you know what this is?

STAMPER: Poison.

MAX: I was using it to make bird food, but what is stopping us from using it to poison fish?

STAMPER: Is that a serious question?

MAX: Yes.

STAMPER: What am I going to do? Pour poison into the lake?

MAX: Why not?

STAMPER: Why not? Because it won't just kill the fish, it'll kill everything else.

MAX: So what?

STAMPER: So we can't just go around killing absolutely everything.

MAX: Is this about the Natterjack Toads?

STAMPER: No, it's not about the Natterjack Toads.

MAX: Then what is it about?

STAMPER: It's about not being…not just killing because…I don't know what it is about, but I won't pour poison in the lake.

MAX: You've gone soft.

STAMPER: I haven't gone soft.

MAX: You're a sympathiser.

STAMPER: No Max, I am not. I just don't want to kill for killing's sake.

MAX: They are all harmful in their own ways. All taking something, and none of them giving anything back. They are all harming my land and they all need to be killed.

STAMPER: Can't you hear what you are saying?

MAX: I know exactly what I am saying and I know exactly what I am doing. I am making this land better, and if you don't want to help me, then I will do it on my own.

MAX takes the poison and exits.

End of scene.

SCENE 3
In which Stamper tries to save a life and Max reveals a leaflet of his own.

STAMPER enters, looking for MAX. When he realises that MAX is not there, he exits. He re-enters with a small box, which he carries delicately, he is heading for the other door. MAX enters, reading a piece of paper, blocking STAMPER's exit.

MAX: Good. I found you. Look at this.

STAMPER attempts to conceal the box, but the toad makes a sound.

MAX: Was that you?

STAMPER: Yes. Little indigestion. Too much red meat I think. What is it?

MAX: A leaflet.

STAMPER: My leaflet?

MAX: No, my leaflet.

STAMPER: You don't have a leaflet.

MAX: I do now.

STAMPER: Where did you get it?

MAX: I made it myself. I am going to make more of them. Then I can give them out to people like us, and then they can copy The Solution for themselves.

The toad makes a noise.

STAMPER: Good! Good. Yes. Very good.

MAX: It is good. You should read it.

STAMPER: Yes, I will. I will. I will read it cover to cover, not just now though.

MAX: Why not?

STAMPER: I'm busy.

MAX: Really? What's in the box?

STAMPER: I had some...some worms in it. I caught some worms. I was going to use them to lure birds in and then I was going to catch them. The birds.

MAX: You were going to catch birds?

STAMPER: Yes, a few.

MAX: But birds are my job.

STAMPER: Yes.

MAX: Team Shotgun.

STAMPER: Yes I know, but you helped me out on the fish front. So I thought I could give you a hand with birds.

MAX: You don't have to worry about the birds, they are taken care of.

STAMPER: Really? How?

MAX: Remember that fishing net?

STAMPER: Yes.

MAX: Let's just say I found a use for it after all.

STAMPER: Poor little birds.

MAX: What?

STAMPER: I said…little fuckers. Let's kill them all.

The toad makes a noise.

STAMPER: Fuck. Excuse me, little burp. Need a bit more fruit and veg in my diet. In fact, that's what I'll do right now. I'll go and get myself an apple.

MAX: *(Taking an apple from his pocket.)* Oh, here you go.

STAMPER: Thank you. Actually, I think I would rather have a plum.

MAX: *(Taking a plum from his other pocket.)* Got one of those too.

STAMPER: Oh good. Too kind. But actually I think that what I would really like is…some melon. Got any melon son?

MAX: No.

STAMPER: Well, bad fucking luck eh? I'll have to go and get some.

The toad makes a noise. STAMPER coughs loudly to counter.

STAMPER: Got a cold coming on I think. Better go and get my melon.

MAX: Hold on.

Pause.

MAX: Something isn't right here.

STAMPER: Isn't it? Seems all right to me.

MAX: No, something is definitely not right.

STAMPER: Max, everything is fine.

MAX: …Listen to my leaflet.

STAMPER: Not right now Max.

MAX: Why not?

STAMPER: I just have things to do.

MAX: Can't they wait?

STAMPER stops. He turns and returns to the room.

MAX: Good. Why don't you sit down?

STAMPER: I would prefer to stand.

MAX: You would be more comfortable sitting.

STAMPER: I like standing.

MAX: But this might take a while.

STAMPER slowly sits.

MAX: The first paragraph mostly explains the old Solution, but here is the paragraph about Part Two. 'It then occurred to us that the problem with the foreign species was that they were not doing enough to justify their presence on the land that supported them. The success of Phase One, opened the door to a new Solution for destroying those newly deemed to be unwanted. We now kill not based on any classification, but rather remove whatever species we deem unwelcome on our land, and we no longer feel bound to provide reasoning or evidence for our decisions.'

STAMPER: Is that really what we are doing now?

MAX: Yes.

STAMPER: We are just killing because we want to.

MAX: Yes.

STAMPER: ...Max, when I first found out about The Solution, I was so pleased. I knew that there were problems and I had finally found something that I could do about them. But I was also pleased because there was a goal. Now I don't know what we are doing.

MAX: We're taking it to the next level. There is always a next level Dad. Removing the foreign species was just the first step. Now that they're gone, we can see clearly how our own species are harming this land, we have to remove them as well. We can't stop Dad, we can never stop. Not now that we have started.

STAMPER: But soon there will be nothing left.

MAX: And what is wrong with that? What's wrong with a land that is empty, as long as it is clean and pure?

STAMPER: Son, can't you hear yourself? You're going to wipe everything out.

MAX: Exactly. And I have you to thank. You showed me the way. Now there is no stopping me. I want to keep going. I want more death. I want more blood. I won't stop until this land is purified. And it is all thanks to you Dad.

The toad makes a noise.

MAX: What was that?

STAMPER: …A toad.

MAX: What?

STAMPER: There is a Natterjack Toad in this box. I was trying to save it, but I see now that there is little point.

MAX: Hand it over Dad.

STAMPER takes out the toad, and hands it to MAX.

MAX: You've done the right thing.

STAMPER: No, son, I don't think I have.

MAX: To victory, to purity and to our new Solution.

MAX crushes the toad in his bare hand.

End of scene.

SCENE 4
In which Stamper asks Eva for help in stopping his out of control son, only to be discovered in his betrayal by a disappointed Max.

STAMPER enters, wheeling on EVA, who is still tied up and gagged.

STAMPER: Eva. Please, I'm not going to hurt you. I am going to untie you.

STAMPER picks up a knife from somewhere in the room. EVA reacts wildly.

STAMPER: Please, don't make any noise. I am going to set you free.

STAMPER is cutting EVA free.

STAMPER: It's Max. He's gone mad. I don't know what to do Eva.

STAMPER cuts the rope that was over her mouth.

EVA: What's going on?

STAMPER: I've created a monster Eva. He has taken my idea, but he has taken it too far. He's going to kill everything. Absolutely everything. We need to do something.

EVA: We?

STAMPER: I can't do it on my own. I was hoping you would come up with something, you're the cleverer one.

EVA: So now you need my help?

STAMPER: Yes.

EVA: You want me to help you?

STAMPER: Please Eva.

EVA: After everything you put me through?

MAX enters, silently.

STAMPER: I know Eva. I know. And I am sorry. But everything I did I thought I was doing it to help us, to help you. But Max, he is not helping anyone. He is ruthless. Ruthless Eva. And we need to stop him.

MAX: ...Oh dear, oh dear, oh dear.

Pause.

MAX: What have we here?

MAX appears, behind them both, holding a large knife.

MAX: I remember when I was invited to family meetings. Not anymore it seems.

STAMPER: Max, it isn't what it looks like.

MAX: And what does it look like, do you think?

STAMPER: It looks like I am freeing her.

MAX: Yes it does.

STAMPER: But I'm not.

MAX: Really?

STAMPER: Well, I am. But only because...because she...

EVA: Wants to help you.

STAMPER: She wants to help us.

EVA: I want to join you Max. I want to help you clean up this land.

MAX: Oh, you do?

EVA: Yes.

STAMPER: She does. That's why I was freeing her.

MAX: You want to help us?

EVA: Yes.

STAMPER: I couldn't believe it either.

MAX: So if I brought a creature of some sort in here, you would kill it for me?

EVA: ...Yes.

MAX: If I brought a rabbit in, you would cut off its head?

EVA: ...Absolutely.

MAX: If I brought a little squirrel in here, you would stab it with this knife?

EVA: ...I would.

MAX: Good. Very good. This is what we've always wanted isn't it Dad? To work together as a family. Well, why don't you two wait up here then? I have a net full of birds waiting to be dispatched, Eva can do it for us. Can't you Eva?

EVA: I'd be happy to.

MAX: ...How nice. Be right back.

MAX exits, the door closes and locks.

EVA: What am I going to do?

STAMPER: Let me think.

EVA: I can't kill those birds.

STAMPER: We can fight him.

EVA: He's too strong Dad, and he has a knife.

STAMPER: I will try and talk my way out of it.

EVA: Do you really think that will work?

STAMPER: Then when he comes back in, I will take hold of him, and you get out as quickly as you can.

EVA: I don't want to leave you here Dad.

STAMPER: Don't worry about me Eva. Get out and run as far as you can. You go and find that perfect world that you told me all about.

EVA: He's coming.

STAMPER: Please go Eva. At least I can do this for you. I can save you from this.

EVA: I can hear him coming.

STAMPER moves in front of the door, EVA behind it, ready to run.

STAMPER: Run Eva, run as far as you can.

EVA: I'll come back.

STAMPER: Don't bother. There is nothing left here.

EVA: Goodbye Dad.

STAMPER: Goodbye Eva.

They wait. The door opens slowly, but MAX is not there.

STAMPER: Go now Eva.

EVA steps out of the door. STAMPER waits, wondering if she made it out. He takes a step towards the door. EVA screams. MAX enters, he is holding EVA, who is now completely wrapped in the fishing net from earlier. She can barely move. MAX still carries his knife.

MAX: She was lying Dad. She lied to you. She didn't want to help us at all. She was trying to escape.

MAX locks the door.

MAX: After me preparing those birds for you, you were going to run away? That is not very grateful Eva. Not very grateful at all.

STAMPER: Let her go Max.

MAX: Oh, I see. So you're in on this as well are you?

STAMPER: Max, let her go. I'll stay here with you.

MAX: How could you do this to me Dad?

STAMPER: Max, please, you have to see what you're doing. You have gone too far.

MAX: Too far? I haven't even got started yet.

EVA: But don't you see Max, you will never be finished. You will kill and kill, and you will never stop.

MAX: If you say so.

MAX drops EVA into her chair. She can barely move. He approaches his father.

STAMPER: Max?

MAX: You have harboured fugitives.

STAMPER: Son?

MAX: You have freed a prisoner.

STAMPER: Put that down.

MAX: You have betrayed our ideology.

MAX begins closing in on STAMPER.

STAMPER: Max, I'm your father. Your flesh and blood. You wouldn't hurt me would you Max? Think about all that I have done for you. All the love that I have given you. Come on Max, please…put it down.

MAX has STAMPER cornered.

MAX: …No.

MAX takes hold of his father.

MAX: You started me on this road Father. You gave me the taste for it. It isn't my fault you can't keep up with what you created.

MAX stabs his father. He holds on tightly until STAMPER stops moving. MAX releases his grip, letting the old man fall to the floor. MAX stands and moves towards EVA.

MAX: Enemies to The Solution cannot be tolerated. Not even if they are my own family.

EVA is sobbing terribly and mumbling to herself and her brother. MAX can take his time; he sings slowly, dances a little.

MAX: Now that we've started killing,
The future looks cheery and bright

He picks her up and begins waltzing with her.

MAX: Because we've started killing
Everything looks like it will come out right.

She attempts to fight, but he is too big and too strong.

MAX: The improvements are plain to see,
The future looks so good to me,
We live life as it is meant to be,
And the reason is just because we...
Started killing.

MAX grabs her by the hair and drags her to the middle of the room. He pushes her head down on the table. She struggles, but it is little use. MAX raises his knife.

MAX: Any last words sister?

EVA: ...When you are the only one left Max, who will you blame?

MAX: This is The Solution.

He brings his knife down with a loud bang.

End of scene.

FINALE

In which Max sits alone in his newly created perfect world.

MAX sits alone in his newly created perfect world.

End of Play.

OTHER KIERAN LYNN TITLES

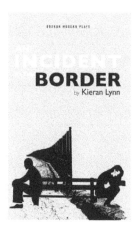

AN INCIDENT AT THE BORDER
9781849434355

"When we came for a romantic walk in the park, we didn't think we would be involved in aninternational crisis…This side of the line, that side of the line. Does it really make that much of a difference which side I am from?"

When a country's new border is drawn, a couple are divided by the line. Under the rigorous eyes of a brand new border guard, they are trapped in an increasingly absurd nightmare, stuck in between two aggressive nations on the verge of war. A comic new play exploring the imaginary lines that divide us and the severe penalties for breaking them…

'Kieran Lynn is notable for the sheer guts with which he animates big, frightening ideas on stage' – **The Scotsman**

'A tight three-hander… Kieran Lynn triumphs here with a sharp, modern satire on a timeless topic' – **What's On Stage**

'Both a clever shot at the bureaucratic chains of command that plague our lives, and a genuinely funny piece of writing.' – **Time Out**

WWW.OBERONBOOKS.COM